Excavations

Excavations

Excavations

© La Belle Inutile Éditions, 2007
ISBN 978-0-6151-7661-1

First Edition

Excavations

✶ ✶ ✶ ✶ ✶

Excavation collage

✶ ✶ ✶ ✶ ✶

Richard Misiano-Genovese

Foreword Notes

Alejandro Puga • Pierre Petiot

✶ ✶ ✶ ✶ ✶

2 0 0 7

Foreword Notes • Alejandro Puga

✳ ✳ ✳ ✳ ✳

EXCAVACIONES. Texto para el libro de Richard Misiano-Genovese

El artista.- Encantado de conocerlo señor. Acabamos de chocar en esta acera desierta. Yo estaba distraído mirando dos láminas anatómicas muy antiguas que decoraban la puerta de un anticuario…Ni siquiera escuché sus pasos, en esta desolada tarde de domingo, día en que acostumbro hacer largos paseos en busca de mí mismo. Soy artista.

El astrónomo.- Yo miraba el cielo en busca de una estrella que aparece algunos instantes antes que Venus pero no quisiera aburrirlo con mis especulaciones cósmicas… Encantado de conocerlo, señor. Nunca vengo a este barrio pues abundan las ruinas y las veredas en mal estado pero hoy, mientras ordenaba unas láminas creadas por el gran Hevelius, pensé en lo saludable que podía ser dar algunos pasos fuera de mi observatorio…Soy astrónomo.

El artista.- Quisiera continuar nuestra conversación, que no seamos apenas dos palabras que se suceden a intervalos regulares en el blanco folio de un libro inédito…Aunque decir inédito es como decir crisálida o magma o música…Oh, adoro expresarme con palabras que denoten fugacidad. La fugacidad es una dama bellísima que sostiene con una telaraña sin araña a todo el Universo ¡Pero cómo me atrevo a hablarle a usted del Universo!..

El astrónomo.- ¡Sublime analogía la suya, estimado desconocido! No se preocupe, estoy habituado a que la gente hable de lo que no sabe…Cuando ello ocurre siento que están en busca de un tesoro que no existe o del secreto de una iluminación a partir del color negro que los pintores flamencos no quisieron tener en cuenta pues con sólo pintar un pliegue lograban el efecto deseado ¡Pero no pretendo inmiscuirme en su florero! Además siento que el inicio de mi frase anterior era correcto pero luego de la letra "o" me fui por las ramas…La comunicación se complica cuando la voz se torna seductora. Otra vez me voy por las ramas…Su voz me seduce, me embriaga… Usted me dijo que es artista de modo que no me fastidiaré cuando se le antoje incluir en su encantador discurso a mis elementos…No me fastidiaré pues no quiero turbar este bello atardecer de invierno poco riguroso, mis preferidos. Ni siquiera hemos tenido niebla este año…

El artista.- Yo también estoy habituado a que la gente hable de lo que no sabe.

Durante la conversación han permanecido en el lugar del choque. De pronto aparece un obrero de edad avanzada con una pala y un martillo. Se detiene muy cerca de ellos y comienza a golpear y luego excavar el pavimento. El anciano hace tanto ruido con su gigante martillo que los personajes deciden alejarse pero luego de caminar algunos metros, se miran, con más atención que la primera vez, y deciden volver al lugar del encuentro. Una fuerza misteriosa dirige a los dos seres hacia el pozo…

El artista.- ¿Quién será este hombre, verdadero titán, que me recuerda a los espectros que el viejo Rembrandt amaba ocultar en sus aceitosas sombras pintadas? ¿Sabe que yo también excavo?

El astrónomo.- Yo también excavo. ¿Quién será este hombre, capaz de manejar una pala que duplica su peso? Se mueve como un ciego pero se debe a que hace su tarea con los ojos cerrados…como los artistas…

El artista.- Parece que nuestro encuentro se está convirtiendo en algo mucho más interesante de lo que creí en un principio…

El astrónomo.- Coincido, mi amigo. No todos los días se produce la colisión de dos solitarios, en una calle desierta, dos solitarios que luego de semejante encontronazo no se insultan, no se ocupan del sexo de la madre ajena…

El anciano comienza a arrojarles grandes paladas de tierra nauseabunda al astrónomo y al artista. De vez en cuando los golpea algún objeto salido de las entrañas de la tierra que el anciano descubre sin asombro alguno: la mitad de un gran pez plateado en perfecto estado de conservación, una llave plateada pero con incrustaciones de oro puro, un canasto de mimbre con orquídeas arqueadas como cejas de esquimal, un Pinocho de yeso, un despertador, una cuna agujereada o baleada, un trozo de mampostería donde se ve la parte central de la Vía Láctea pintada con gran maestría...

El artista.- Hablando de madre ajena...Yo también excavo (mirando sus ropajes estropeados). No se lo dije antes pues me había quedado pensando en una misiva que espero desde hace 49 años...Yo también excavo pues es una curiosa manera de ahondar en mis miradas, de no ser solamente dos ojos destinados a cubrirse de cataratas...Yo excavo. Excavo. Excavo en la tibieza de la cama cuando mi amada acaba de dejarla, excavo las revistas que algún amigo olvida intencionalmente en mi mesa de estudio, excavo incluso su negra bóveda celeste...Ni negra, ni bóveda, ni celeste... apenas un orgasmo de semen desconocido, una leche desparramada con descaro en todas direcciones...

El astrónomo.- Coincido con usted, estimado amigo. Me refiero a lo de la madre ajena...Disculpe, pero no pude escuchar el resto de su discurso. Sus tres últimas palabras...negra bóveda celeste...Oh, yo la excavo todas las noches. Casi nunca duermo de noche pues voy a un bosque, el único que queda en esta ciudad...Dije bosque cuando en verdad debería haber dicho pequeño bosque. Es un error no hacer interferir al diminutivo cuando es preciso. La expresión puede también ser una presión pasada...diría un poeta que admiro mucho, un poeta surrealista sudamericano. Su signo es Sagitario y se parece mucho a usted aunque es más joven...

Se oyen las últimas paladas. El anciano ha hecho en pocos minutos un enorme hoyo que súbitamente se llena de agua. Agua muy pura, tan pura que se ven hermosos peces multicolores rodear un deslumbrante banco de coral. Un delfín aparece y provoca una larga exclamación. Pero esta idílica visión dura poco tiempo. Ha anochecido. En el centro exacto del negro pozo se ve una luna llena titilando como un farol japonés antiguo. El anciano huye mientras el artista y el astrónomo descubren en la acera de enfrente una galería muy modesta aunque las dos columnas que dominan su fachada son de un apreciado mármol que recuerda el de algunas escalinatas venecianas. Sus dos vidrieras son de translúcido papel rasgado. El viento débil sacude imperceptiblemente los senos, las largas cabelleras incoloras, las empapadas vulvas de unas magas involuntarias. En la marquesina violeta, escrita en letra itálica blanca, la palabra EXCAVACIONES.

La escena se oscurece mientras los dos personajes nadan lentamente en dirección de la galería...

Alejandro Puga
15.8.2006

* * * * *

Foreword Notes • Alejandro Puga

✶ ✶ ✶ ✶ ✶

EXCAVATIONS. Texts for a book by Richard Misiano-Genovese

The artist.- Enchanted to know you Sir. We finished beating on this desert sidewalk. I was distracted observing two very old anatomical laminaë that decorated the door of an antique dealer... Not even I listened to his steps, in this desolate Sunday afternoon; a day in which I am used to making lengthy strolls in search of myself.
I am an artist.

The astronomer.- I watched the sky in search of a star that appears some moments bfore Venus but did not want to bore it with my cosmic speculations... Pleased to know you Sir. I never come to this quarter since the ruins and the footpaths abound in bad state but today, meanwhile I was arranging a few plates created by the great Hevelius, I thought about how healthy it could be to take some steps outside my observatory...
I am an astronomer.

The artist.- Wanted to continue our conversation, that we should not be scarcely two words that happen at regular intervals on the white sheet of paper of an unpublished book...Although to say unpublished is like to say chrysalis or magma or music Oh, I adore expressing myself with words that should denote fleetingness. The fleetingness is that most beautiful lady who maintains all the Universe, a spiderweb without a spider...
But how dare I to speak to to you of the Universe!

The astronomer. - Dear stranger, his sublime analogy! I do not worry, I am accustomed that people speak of what it is unknown. When that happens I feel that they are in search of a treasure that does not exist or of the secret of illumination from the black color that the Flemish painters did not want to bear in mind since in spite of only painting a crease they were achieving the desired effect! But I do not claim to interfere in his vessel! Also I feel that the beginning of my previous phrase was correct but after the letter "o" I went away for the branches... communication complicates when the voice becomes seductive. Again I go away for the branches... Its voice seduces me, intoxicates me... You told me that he is an artist so that I will not go wrong when he feels like including my elements in his charming speech... I will not go wrong since I do not want disturb this beautiful evening in a slightly rigorous winter, my favorite. We have not even had fog this year...

The artist. - I also am accustomed that people speak of what it is unknown.

During the conversation they have remained in the place of the shock. Suddenly there appears a worker of advanced age with a shovel and a hammer. He stops very closely to them and begins to strike and soon excavate the pavement. The elder makes so much noise with his giant hammer that the people decide to move away but after walking some feet, they look, with more attention than the first time, and decide to return to the place of the encounter. A mysterious force directs both beings towards the well...

The artist.- Who will be this man, true titan, that reminds me of the phantoms that the old Rembrandt loved hiding in his oily shades of paint? Is it known that I also excavate?

The astronomer.- I also excavate. Who will be this man, capable of handling a spade that duplicates his weight? One moves as a blind person but it is due to the fact that it does his task with eyes closed... like the artists...

The artist.- It seems that our encounter is becoming something much more interesting than I believed at first...

The astronomer.- I agree, my friend. Not every day the collision of two solitares takes place, in a desert street, two solitares that after similar collision are not insulted, do not take care of the sex of other people's mothers...

The elder begins to throw great shovels full of nauseous earth at the astrologer and the artist. Occasionally they are struck by some object gone out of the bowels of the earth that the elder discovers without any astonishment: a silver-plated key but with pure gold incrustations, a wicker basket with orchids arched as Eskimo's eyebrows, a plaster Pinocchio, an alarm clock, a pierced cradle or baleada, a piece of crockery where there is the central part of the Milky way seen, painted with great mastery...

The artist. - Speaking of other people's mothers… I also excavate (looking at his battered robes). I did not say it before because I had continued thinking about a letter that I have been hoping for 49 years… I also excavate since it is a curious way of going deep into my gazes, of not being only two eyes destined to be covered by cataracts... I excavate. I excavate. I excavate in the tepidity of the bed when my love finishes leaving it, I excavate the magazines that some friend intentionally forgets on my study table, I excavate even his black celestial vault... Neither black woman, nor vault, not celestial... scarcely an orgasm of unknown semen, a milk spread with rudeness in all directions...

The astronomer. - I agree with you, dear friend. I refer to that thing about the foreign mother... Forgive me, but I could not listen to the rest of his speech. His last three words ... black celestial vault ... Oh, I excavate it every night... I hardly ever sleep at night since I go to the forest, the only one that remains in this city... I said forest when really I should have said small forest. It is an error not to exclude the small one when it is necessary. The expression can be also a past pressure... there would say a poet who very much admired, a surrealistic South American poet. His sign is Sagittarius and he looks very much like you although he is younger...

The last shovels full are heard. The elder has made an enormous hole in a few minutes that suddenly fills with water. Very pure water, so pure that they see beautiful multicolored fish surrounding a dazzling bank of coral. A dolphin appears and provokes a long exclamation. But this idyllic vision lasts little time. It has gotten dark. In the exact center of the black well a full moon is seen as shades of an ancient Japanese lantern. The elder flees meanwhile the artist and the astronomer discover on the opposite sidewalk a very modest gallery, two columns of that dominate the facade are of a valued marble that reminds one of some Venetian staircases. The two show windows are of translucent torn paper. The weak wind imperceptibly shakes the bosoms, the long colorless hairs, the drenched vulvas of a few involuntary magicians. In the violet canopy written in white italic letters, the word EXCAVATIONS.

The scene is darkened while two persons wallow slowly in the direction of the gallery.

Alejandro Puga
15.8.2006

✳ ✳ ✳ ✳

Foreword Notes • Pierre Petiot

* * * * *

Lire au Travers des Pages

A première vue, on pourrait songer que c'est à un plaisir de vandale que Misiano-Genovese nous invite ici. Mais il n'en est rien. Ou pas tant. Car à mieux y regarder on se rend vite à l'évidence que ce qu'il y a de violent et même de destructif dans l'art de Misiano-Genovese finit toujours par s'inverser toujours en un miroitement d'innocences. Au fond de ses déchirements, aussi dévorants et rageurs qu'ils puissent paraître— et soient — il passe toujours l'ombre soyeuse d'une aube.

Ainsi renverse-t-il ici pour nous l'art de déchirer en un jeu subtil de rencontres. A notre geste négligent de feuilleter, il attache subrepticement une passion de lire, qui n'est plus cet habituel désir où nous attendions de saisir le réel entre les lignes, mais plutôt comme le vertige de le capter très littéralement au travers des pages.

Dans un retour du courrier inattendu, notre vision, d'abord rendue sourcilleuse par l'évidence de la profanation, se mue lentement puis se recouvre tout à fait en un bonheur de parcourir enfin un livre selon sa perspective de traverse, celle de l'intensité des possibles qui s'y nouaient jusqu'alors à notre insu, et qui auraient pu sans doute se révéler à notre regard s'il savait encore enflammer les pages.

Et c'est comme si le livre tout à coup était devenu transparent. C'est comme s'il se disait à chaque page, lourd de toutes les mutations et de toutes les combinatoires envisageables. C'est comme un jardin soudain que l'acte d'abord étrange de Misiano-Genovese nous révèle dans la volte face, d'abord toute négative, puis au revers, étonnamment fructeuse, des feuilles. Nous apprenons qu'un livre sait se lézarder et tout ce qui peut se jouer de murmures et d'éclairs dans l'intimité blanche qui par instants s'exhibe de sa chair. Ivre le livre... Rendu à la fierté et à la fièvre libres et inaugurales du verbe. Ivresse par quoi la forme se connait comme acte dans le déchirement d'où elle émerge.

Ne nous faut-il pas admettre que cette effraction où se ruine le rectangle toujours hautain et glacé des pages nous fait du bien, admettre qu'en son déchirement nous le voyons enfin rêver, cet obsédant rectangle? Faut-il ajouter que pareille révélation nous soulage ? Et que mystérieusement nous mêmes, il y a bien longtemps, nous rêvâmes qu'il en advienne ceci, ce qu'en a fait Misiano-Genovese, précisément, et qui est comme un bruissement de rencontres.

Reste-t-il d'ailleurs quelque chose du livre original ? On serait tenté de dire qu'il n'en reste plus guère que des cendres. Il n'en reste plus en quelque sorte que l'absence des rencontres qui n'ont pas eu lieu pour nous. Rien d'autre qu'une habitude de livre. Quelque chose comme l'emballage et les scories de la merveille. Un ob-jet. C'est à dire étymologiquement, quelque chose qui, jeté devant notre vision, l'embarasse et la gêne. Ce sur quoi elle trébuche et achoppe. Et puis ce qui reste du livre aussi, c'est la colle. La colle, qui, par la tranche continue de réunir les feuillets dans la reliure. Par routine. La colle qui, enfin rejetée de l'acte véritablement mental du collage, vient affirmer la preuve de ce qu'avait annoncé Max Ernst selon quoi *"si c'est la plume qui fait le plumage, ce n'est pas la colle qui fait le collage"*. Et ceci n'est pas sans conséquences car il apparaît désormais que la colle des collages n'était rien d'autre que l'écueil où venait échouer et se briser la dynamique créatrice de la pensée visuelle du spectateur qui nous est ici au contraire restituée dans sa respiration et l'irréversibilité de sa marche au coeur du mouvement, que Misiano-Genovese a approfondi pour nous, des pages que l'on tourne.

Pierre Petiot 2006

* * * *

Foreword Notes • Pierre Petiot

✶ ✶ ✶ ✶ ✶

Reading Through the Pages

One may at first think that Misiano-Genovese invites us to the questionable pleasures of vandalism. But that's not the case. Or not that much. Because when looking closer, one reaches the evidence that what is violent and destructive in Misiano-Genovese's art always finally reverses itself in a shimmering of innocence. In the depths of his tearings, how devouring and raging they may be - and are - always the silky shadow of a dawn is passing.

Here, is the action of tearing inverted into the subtle play of encounters. Misiano-Genovese surreptitiously connects our casual gesture of turning over the pages of a book to a passion of reading that is no longer this usual desire of expecting the Real *between* the lines but rather like the vertigo of capturing it very literally *through* the pages.

By a strange "return of post", our vision which was left somewhat frowning when initially confronted with the evidence of the profanation, is slowly transmuted and then finally finds itself in the pleasure of browsing through a book according to its transverse perspective. According to the lines of a field opened by the intensity of the possibilities that were previously laying or playing there, within the thickness of the pages, without us being aware of them. All the possibilities that would maybe have been revealed to us if our sense of sight was still able to set pages on fire.

And suddenly it seems that the book has become transparent. As if it was revealing itself behind, within and through each one of its pages, loaded with all its possible mutations and combinational abilities; and it is something like a garden that Misiano-Genovese's odd gesture uncovers for us in the initially quite negative but soon surprisingly fruitful turning of the torn pages. We learn then that a book knows how to crack like a wall, and all the whispers and flashes of lightning that lay in the white intimacy of its flesh. *Ivre livre*... Drunken book. Sent back to the free and initial pride and fever of the Verb. The quiet ecstasy by which the Form knows itself as an action, in this tearing out of which it emerges.

Yet, don't we have to admit that this breaking in, by which the contemptuous and frozen rectangle of the pages is ruined, feels good to us? Don't we have to admit that in its tearing, we finally see this obssessing rectangle *dream*? It is necessary to add that such a revelation soothes us? Also that in some mysterious way we secretly dreamed long ago that out of it, *this* occcured: precisely what Misiano-Genovese made of it, which sounds to the mind like a rustling of encounters? Then, what is left of the original book all well considered? One would tend to say "something like ashes". What is left of the book is only the absence of the encounters that we missed and did not occur for us. The usual and daily failure. Nothing else than the *habit* of a book. Something which now looks like like the useless packaging of the marvellous. An ob-ject. That is, etymologically, something that is thrown in front of us and that hinders and embarrasses our vision. Something that was thrown there with the hidden objective of making our vision stumble and stop.

However, what is left of the book too, is the *glue*. The glue that connects the back of the pages in the binding. This ugly glue which, to our relief, is definitely rejected out of the authentically mental act of the collage as now some sort of useless routine, and this comes happily to confirm Max Ernst's sentence by which "*si c'est la plume qui fait le plumage, ce n'est pas la colle qui fait le collage*"; and although a little change it is not without consequences. Because it now appears that in the collage, the glue was nothing else than the reef on which the creative dynamics of the viewer's visual thought was driven ashore and broken; but here and now the opposite; this dynamics is given back to us in its breath and the irreversibility of its pace, through the very core of this movement, that Misiano-Genovese has deepened for us, of pages that are turned.

Pierre Petiot 2006

✶ ✶ ✶ ✶ ✶

Excavations

At first glance, a collage of disparate images torn, randomly, and brought together on the same spatial plane. This achievement of recreating a newer image by this method, is brought about by applying two or more separate images, one layered upon the other attached in loose fashion, then the act of tearing away bits of the upper image, here and there, to reveal the image just below its surface. In this way the images are brought together in a rather jarring and forceful manner, with often revealing results of a new hybrid image. This visual poetry is brought about by the randomness of the process.

Misiano-Genovese 1985

✳ ✳ ✳ ✳ ✳

Excavations

Excavations are collages made using a method developed in 1985 by Richard Misiano-Genovese, in which pictures or images are glued together in layers, and then a layer or layers are ripped in places, revealing the underlying image.

Excavation Novels

Excavation novel(s) are collages, or more directly décollages in which ordinary bound books are treated to the same method of ripping or cutting away of page fragments to reveal the underlying page, left and right of the margins of the bound page. This method encourages the occurrence of 'chance poetry' in newly assembled words and sentences (and/or images) brought together in the space left by the missing fragments. This method of décollage developed in 2004 by Richard Misiano-Genovese.

"Fortunately, somewhere between chance and mystery lies imagination, the only thing that protects our freedom, despite the fact that people keep trying to reduce it or kill it off altogether."

— LUIS BUÑUEL

Definitions and Statistics

1) " Photo" -- In the context of Photo Collages

A photograph (often just called a photo) is an image (or a representation of that on e.g. paper) created by collecting and focusing reflected electromagnetic radiation. The most common photographs are those created of reflected visible wavelengths, producing permanent records of what the human eye can see.

Most photographs are made with a camera, which focuses the light onto either photographic film or a CCD or CMOS image sensor. Photographs can also be made by placing objects on photo-sensitive paper and exposing it to light (the result is often called a photogram) or by placing objects on the platen of a flatbed scanner (see scanner art).

History and special effects

Most traditional photographs are produced with a two-step chemical process. In the two-step process, the film holds a negative image (colours and lights/darks are inverted), which is then transferred onto photographic paper as a positive image. Another widely used film is the positive film used for producing transparencies, usually mounted in cardboard or plastic frames called slides. Slides are widely used by professionals mostly due to their sharpness and accuracy of colour rendition. Most photographs published in magazines are still originally taken on colour transparency film. One of the most famous transparency films is Kodachrome®.

Originally almost all photographs were black and white. Although methods for developing colour photos were available as early as the late 19th century, they did not become widely available until the 1940's or 50's, and even in until the 1960's most photographs were taken in black and white. Since then, colour photography has dominated popular photography, although the black and white format remains popular for amateur photographers and artists. Black and white film is considerably easier to develop than colour.

✱ ✱ ✱ ✱ ✱

2) "Collages" -- In the context of Photo Collages

Collage is the assemblage of different forms creating a new whole.

For example, an artistic collage work may include newspaper clippings, ribbons, bits of colored or hand-made papers, photographs, etc., glued to a solid support or canvas.

Decoupage is a type of collage usually defined as a craft. It is the process of placing a picture onto an object for decoration. Often decoupage causes the picture to appear to have depth and looks as though it had been painted on the object. The basic process is of gluing (or otherwise affixing) a picture to something to be decorated, then adding further copies of the picture on top, progressively cutting out more and more of the background, giving the illusion of depth in the picture. The picture is often coated with varnish or some other sealant for protection.

Collage
Cubomania is a collage made by cutting an image into regular squares which are then reassembled automatically or at random. Inimage is a name given by René Passeron to what is usually considered a style of surrealist collage (though it perhaps qualifies instead as a décollage) in which parts are cut away from an existing image to "reveal" another.

Misiano-Genovese also introduced the "excavation" collage (this also includes elements of décollage) which is the layering of printed images, loosely affixed at the corners and then tearing away bits of the upper layer to reveal images from underneath, thereby introducing a new 'collage' of images.

www.encyclopedia.laborlawtalk.com /Collage

✳ ✳ ✳ ✳ ✳

Décollage
Décollage, in art, is the opposite of collage; instead of an image being built up of all or parts of existing images, it is created by cutting, tearing away or otherwise removing, pieces of an original image. Examples include inimage or etrécissements and excavations.

The French word "décollage" translates into English literally as "take-off" or "to become unstuck." The term is now commonly used in the French language in regard to aviation (as when an airplane lifts off the ground).

A similar technique is the lacerated poster, a poster in which one has been placed over another or others, and the top poster or posters have been ripped, revealing to a greater or lesser degree the poster or posters underneath. Although artist Mark Kostabi claims that "Mimmo Rotella invented the technique of using torn posters to make art in the early 1950's", examples of the genre done without any surrealist or artistic intent predate this, as do Raymond Hains'. The lacerated poster was an artistic intervention that sought to critique the newly emerged advertising technique of large-scale colour advertisements. In effect, the décollage destroys the advertisement, but leaves its remnants on view for the public to contemplate. The lacerated poster became an art form as early as 1949.

Lacerated posters are closely related to Richard Misiano-Genovese's practice of "excavations."
The most celebrated artists of the décollage technique, especially of the lacerated poster, are François Dufrene, Jacques Villeglé, Mimmo Rotella and Raymond Hains. Often these artists worked collaboratively and it was their intention to present their artworks in the city of Paris anonymously. These four artists were part of a larger group in the 1960's called Nouveau Réalisme (New Realism), Paris' answer to the American Pop movement. This was a mostly Paris-based group (which included Yves Klein and Christo and was created with the help of critic Pierre Restany), although Rotella was Italian and moved back to Italy shortly after the group was formed. A contemporary artist employing similar décollage techniques is Mark Bradford, who lives and works in Los Angeles.

It can be argued that the depliage is a form of décollage, as it is made by initially removing the staples from a staple-bound magazine.

http://www.answers.com/topic/décollage

* * * * *

Collage and the Law

When collage uses existing works, the end result is what copyright scholar's call a derivative work Both the derivative work and the originals have copyrights associated with them.

Due to redefined and reinterpreted copyright laws and hugely increased financial interests, some forms of collage art have been all but outlawed in some areas, for instance in the area of sound collage (hip hop).

Examples of collage art that have run afoul of modern copyright are The Grey Album and Negativland's U2.

http://www.economicexpert.com/a/Collage.htm
http://www.calsky.com/lexikon/en/txt/r/ri/richard_genovese.php

Inimage is a name given by René Passerson to a style of surrealist collage (though there may, technically, be an argument as to whether it really qualifies as a collage) in which parts are cut away from an existing image to "reveal" another.

Collages produced using a similar or perhaps identical method are called etrécissements by Richard Misiano-Genovese from a method first explored by Marcel Mariën. Misiano-Genovese has also introduced the "excavation" collage which is the layering of printed images, loosely affixed at the corners and then tearing away bits of the upper layer to reveal images from underneath, thereby introducing a new 'collage' of images.

www.onlineencyclopedia.org /c/co/collage.html

"I'd still like to say how much I am impressed – sometimes with the cruelty of the imagery; always with its impact."

—JH MATTHEWS 1984

Excavations are collages made using a method developed in 1985 by Richard Misiano-Genovese, in which pictures or images are glued together in layers, and then a layer or layers are ripped in places, revealing the underlying image.

www.sciencedaily.com /encyclopedia/surrealist_techniques

Excavation novel(s) are collages, or more directly decollages in which ordinary bound books are treated to the same method of ripping or cutting away of page fragments to reveal the underlying page, left and right of the margins of the bound page. This method of décollage developed in 2004 by Richard Misiano-Genovese.

homebusinessforums.com /index.php?title=Grattage

"Nascent Aphrodite (Series), I" - 1985

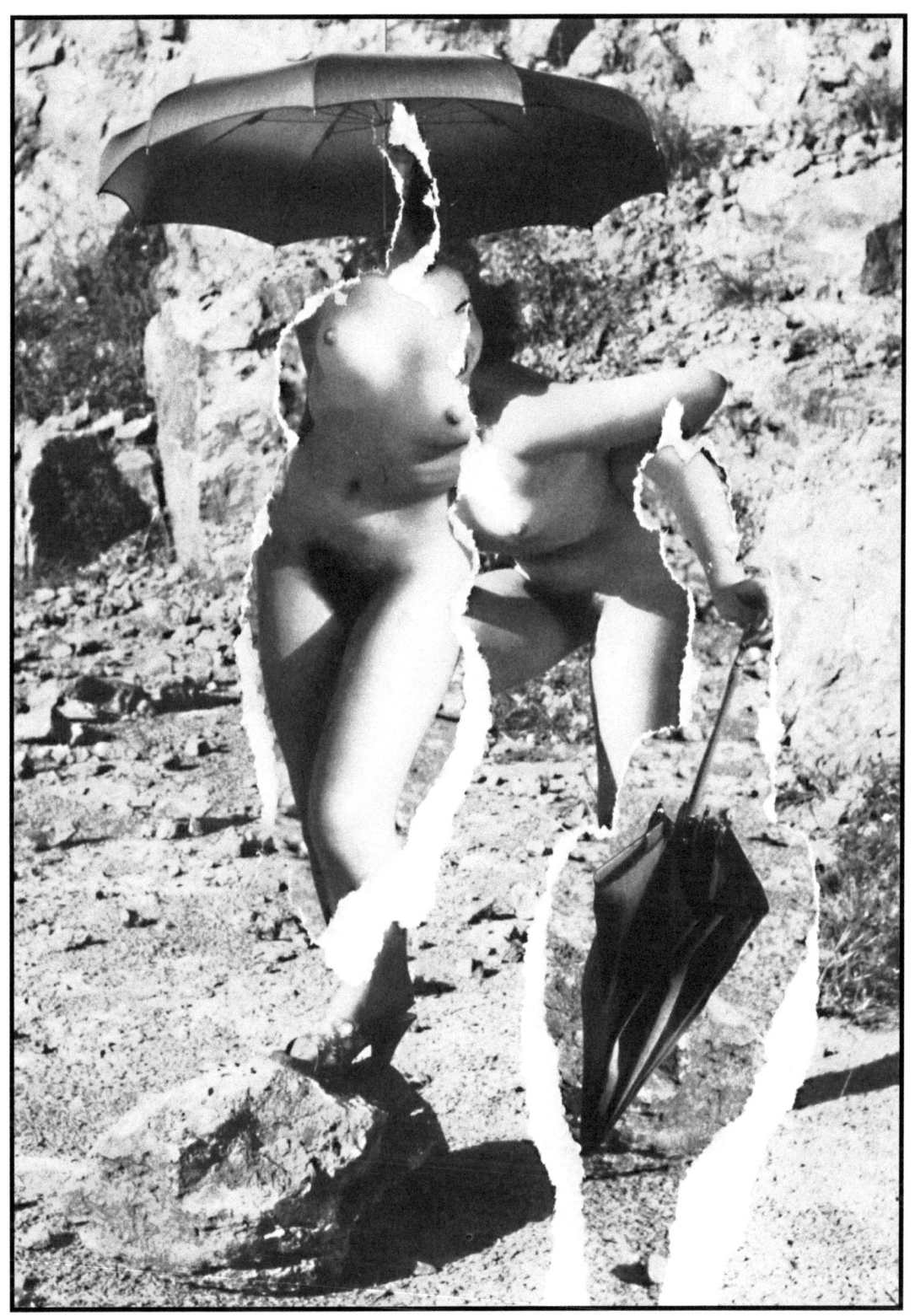

"Nascent Aphrodite (Series)" - 1985

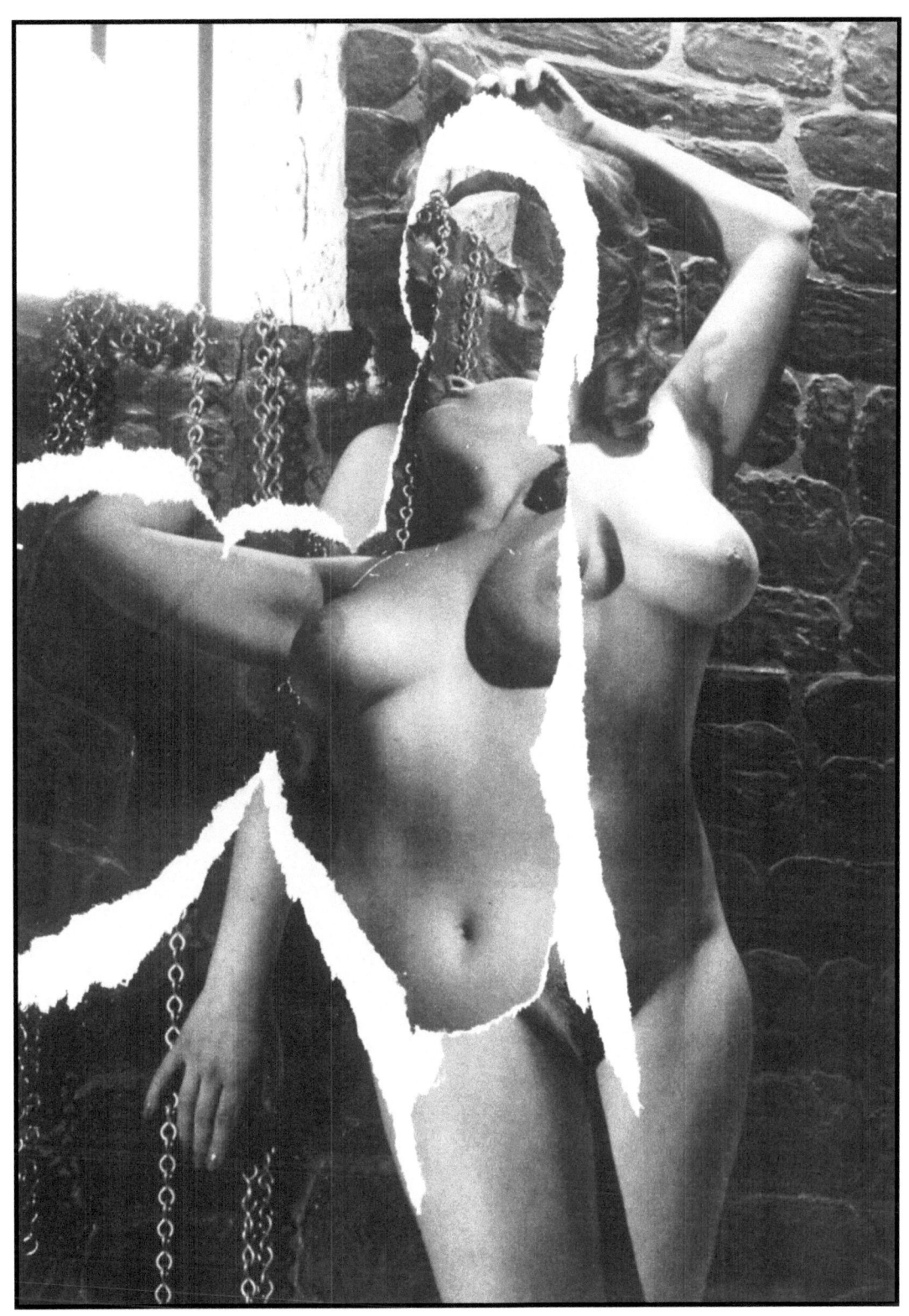

"Nascent Aphrodite (Series) - 1985

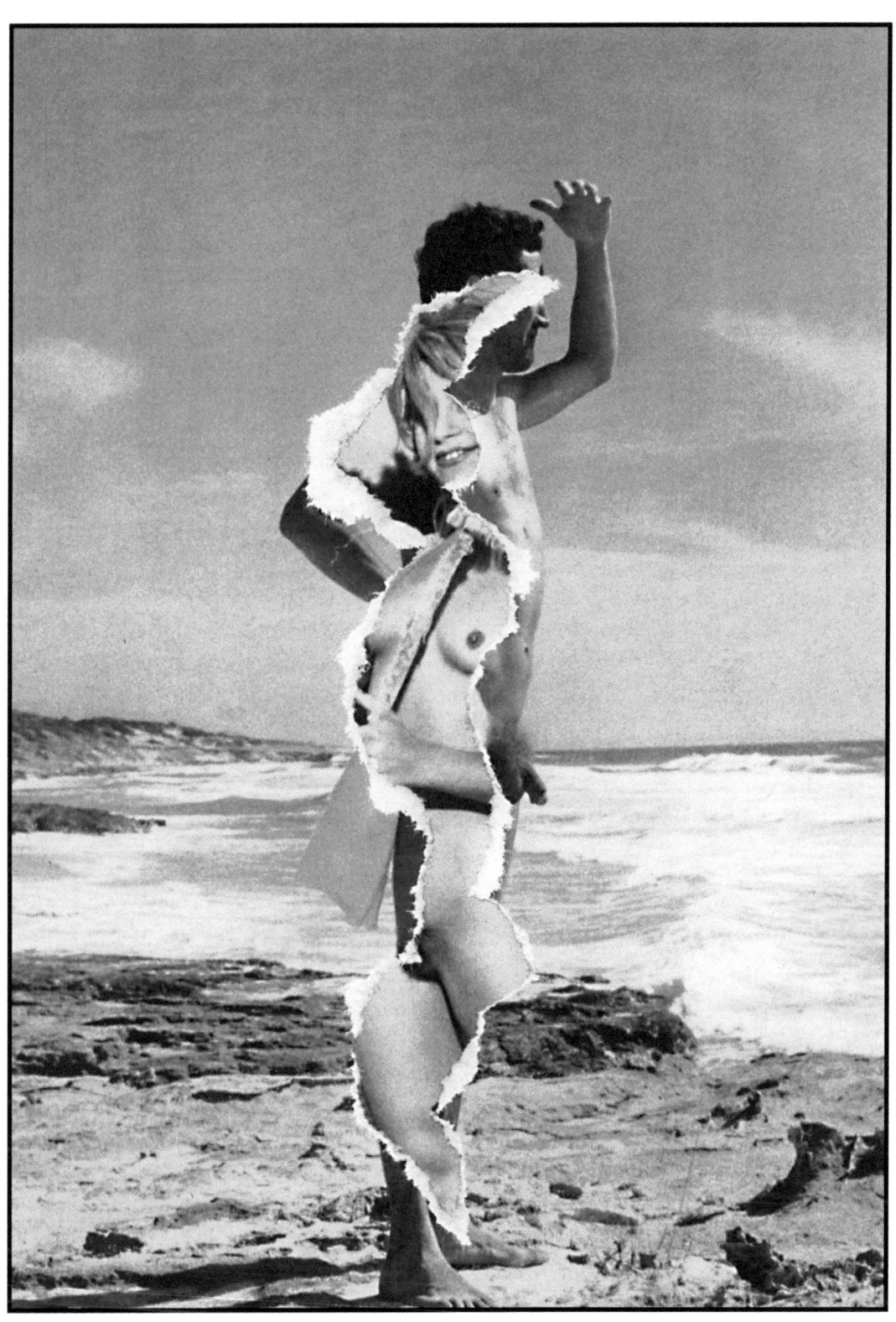

"Penthesilea (Series)" - 1985

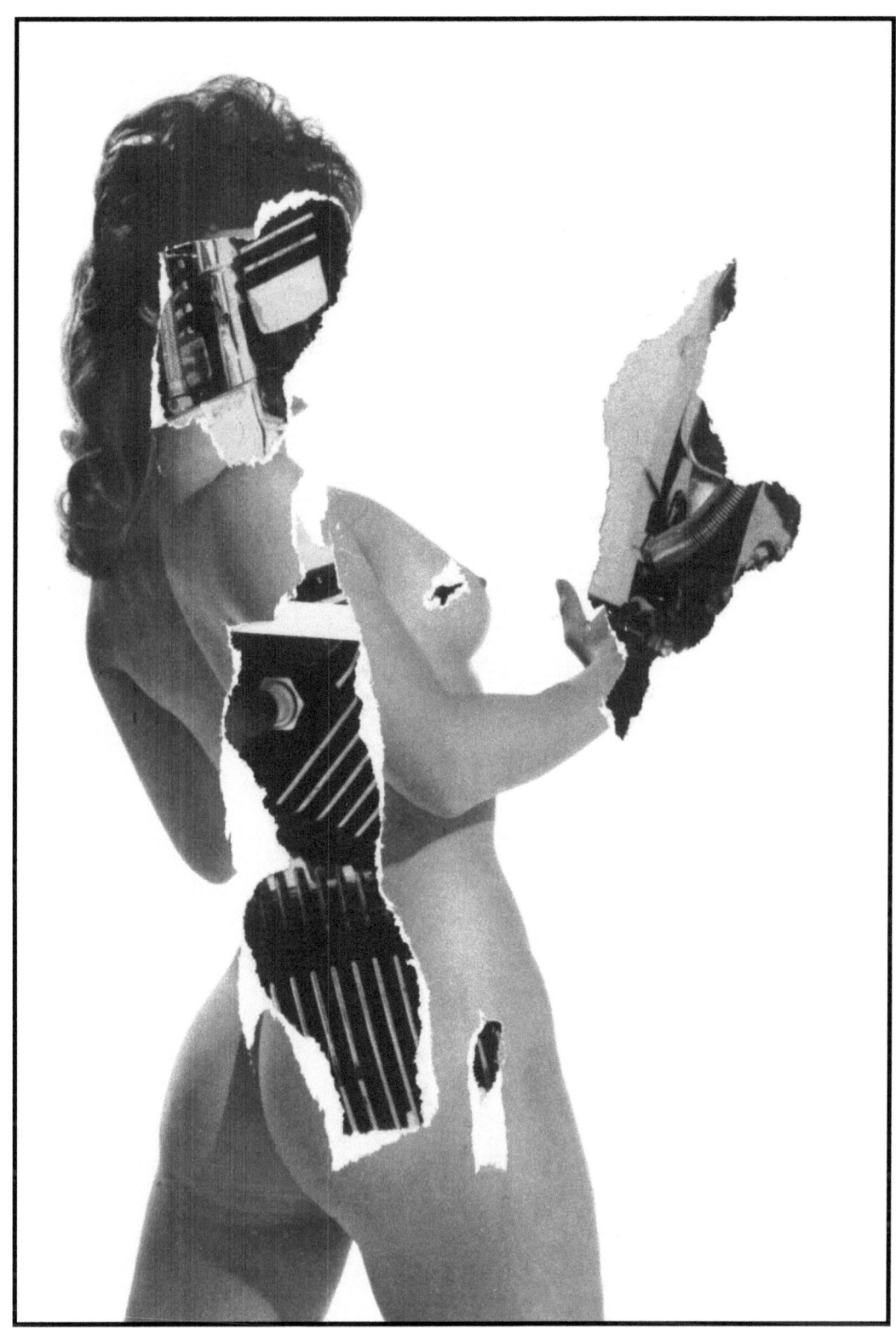

"E-Visceral Rhaphsodies (Series)" - 1990

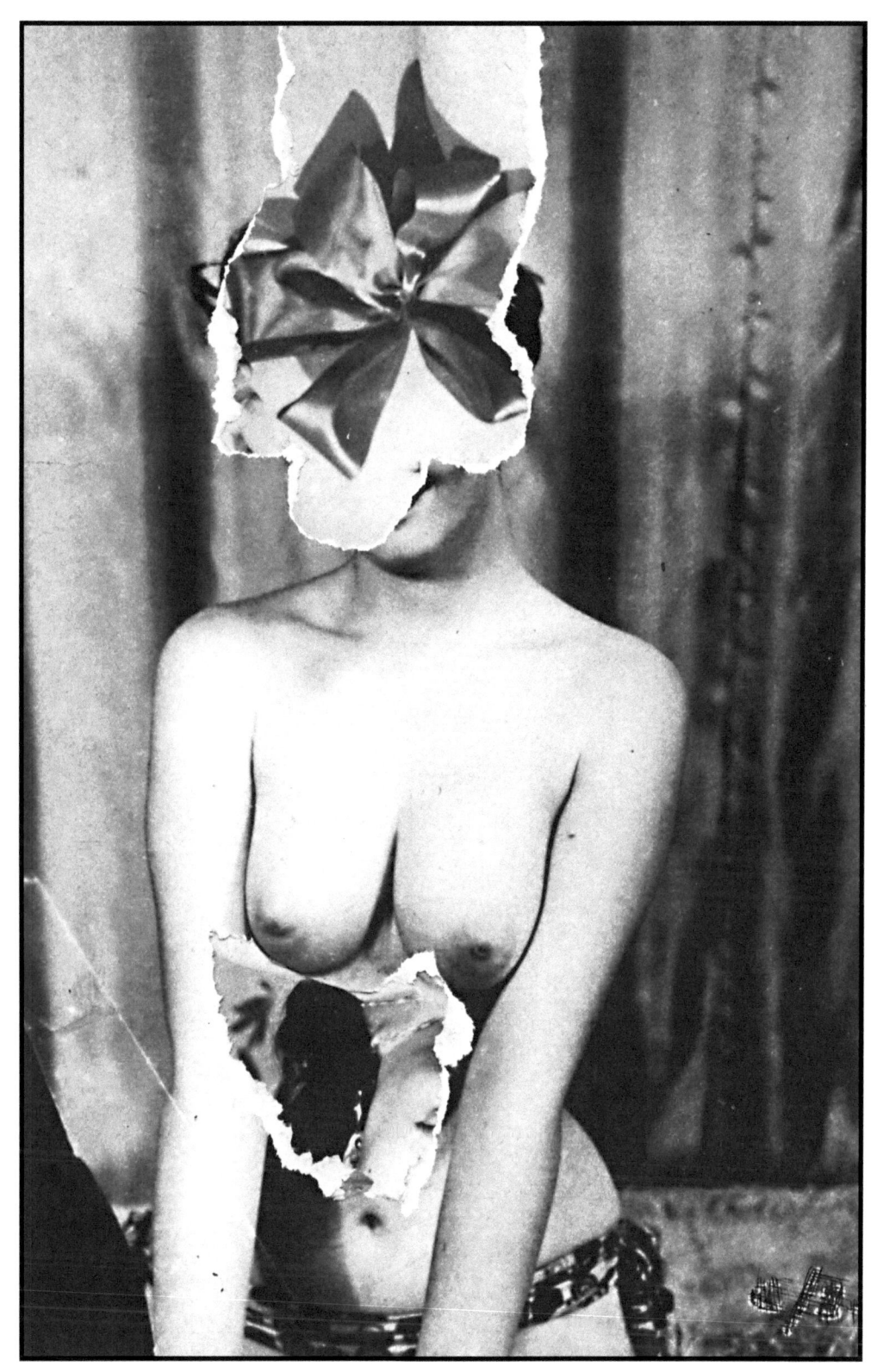

"E-Visceral Rhaphsodies (Series)" - 1990

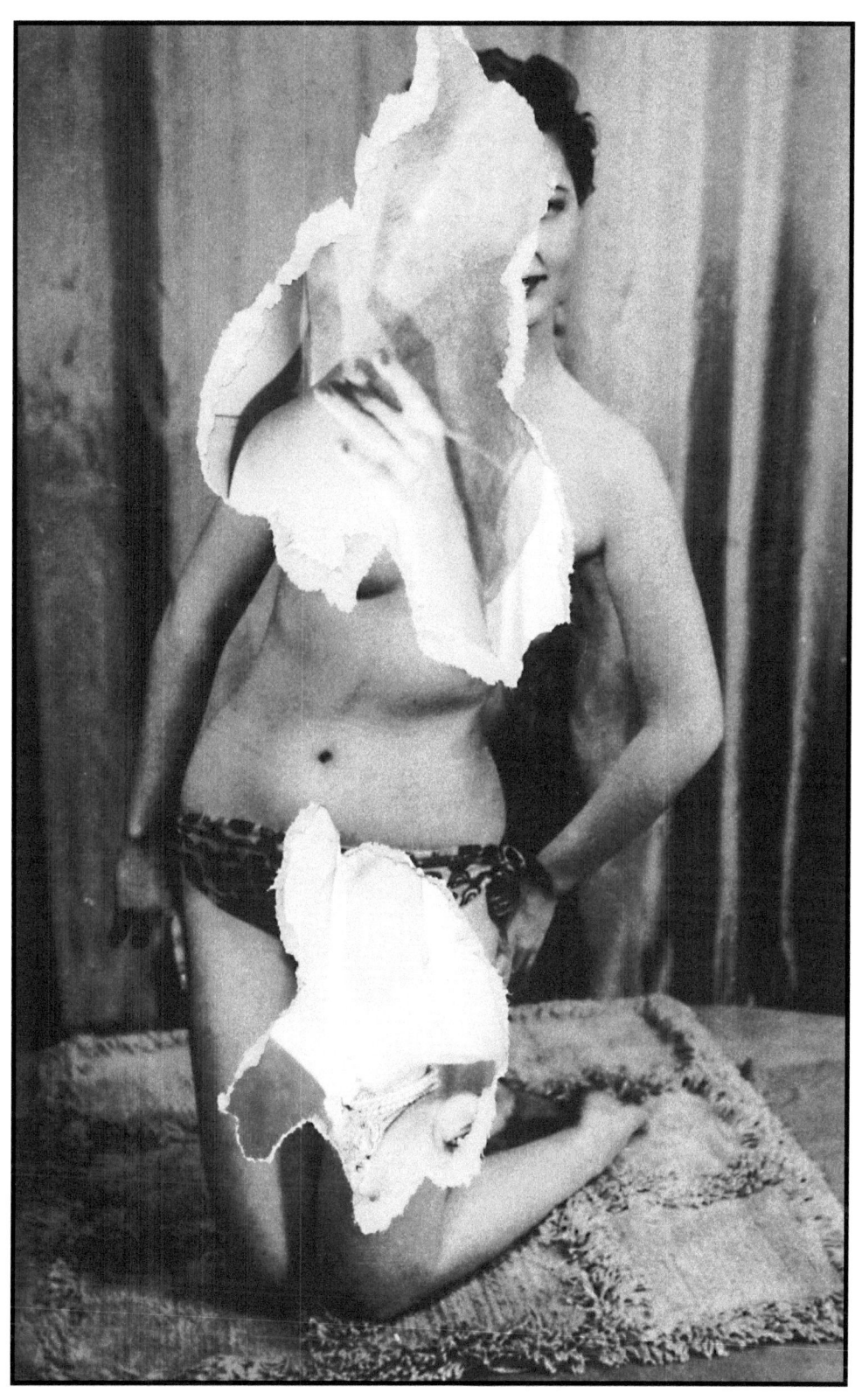

"E-Visceral Rhaphsodies (Series)" - 1990

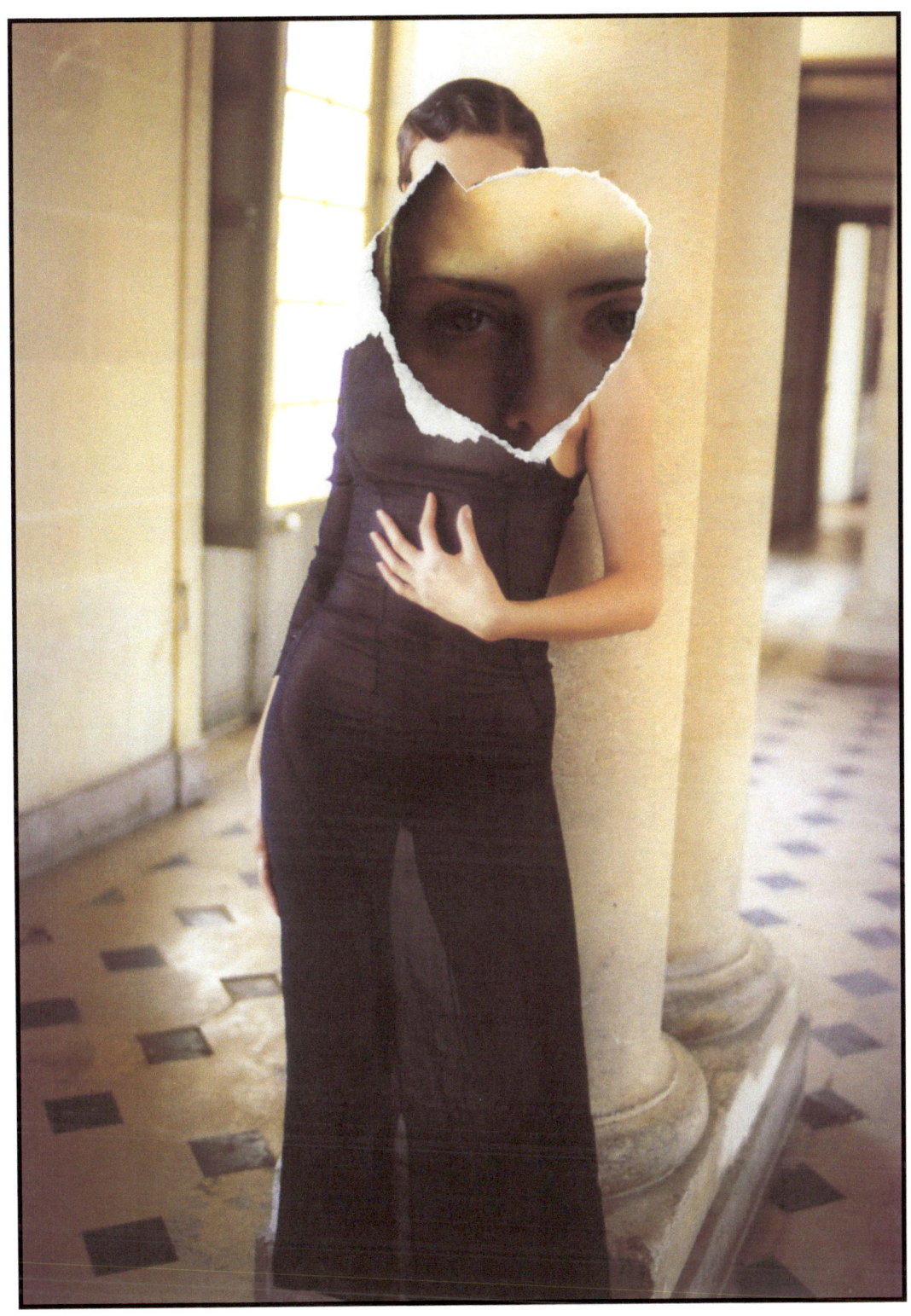

"E-Visceral Rhaphsodies (Series)" - 1990

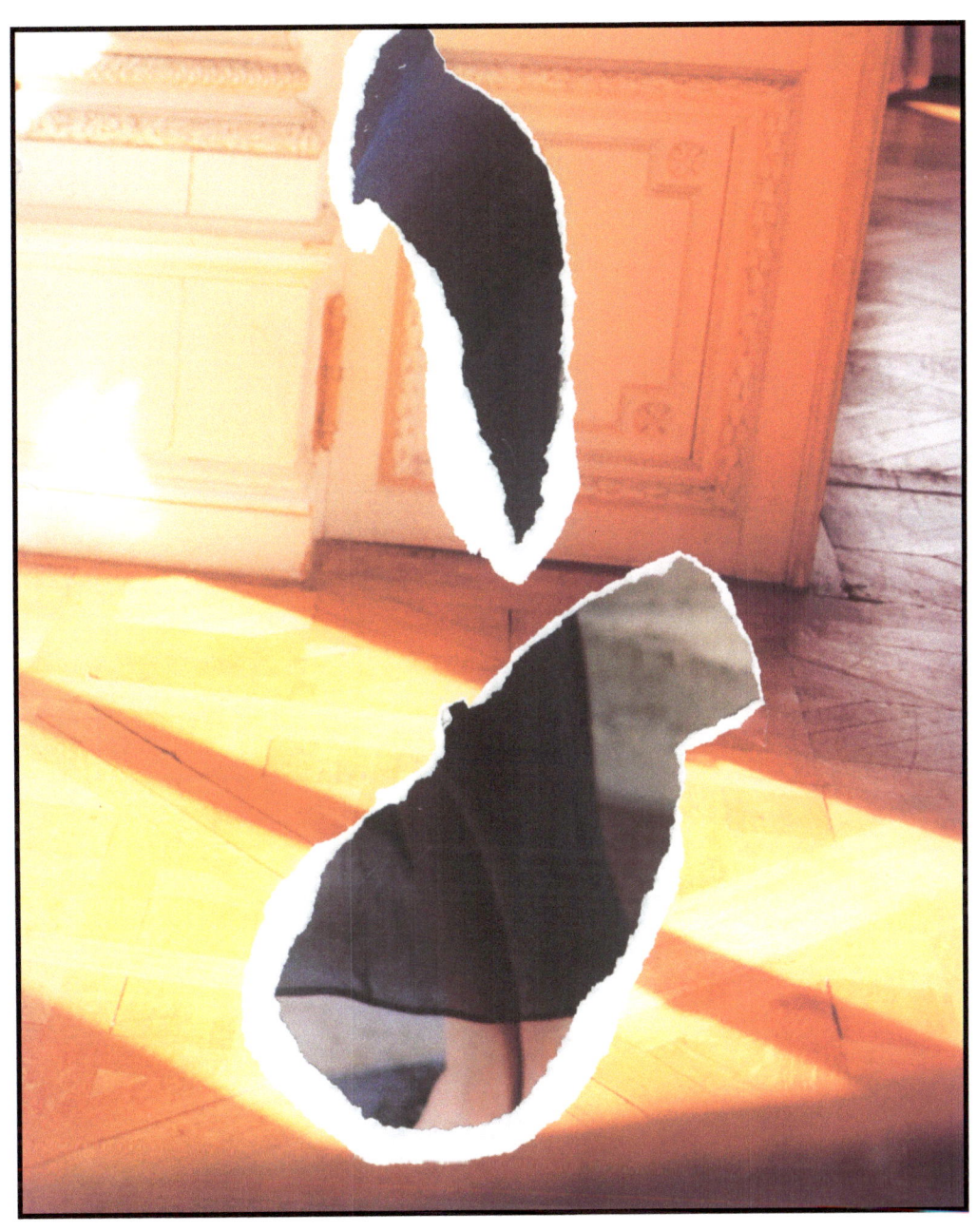

"E-Visceral Rhaphsodies (Series)" - 1990

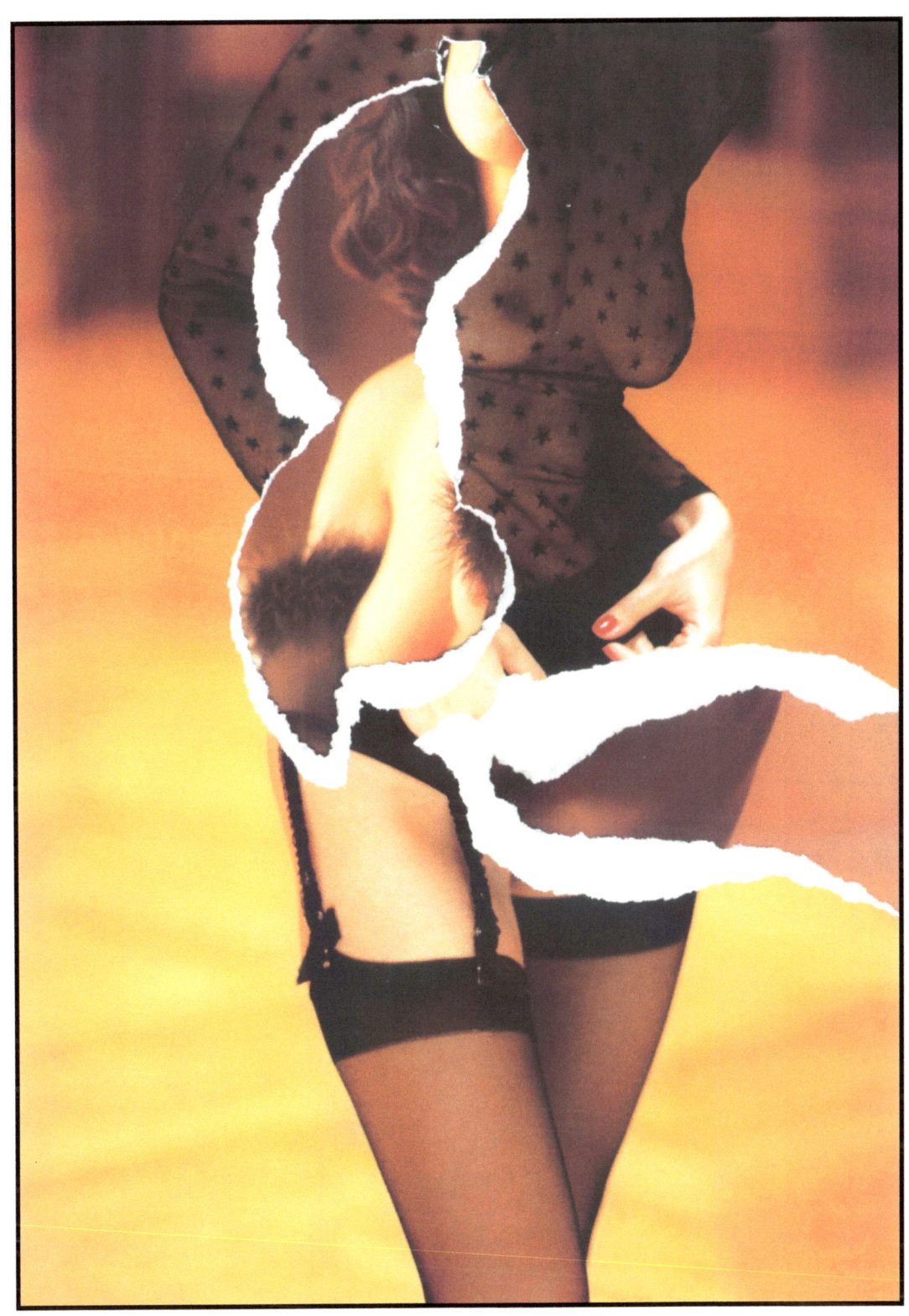

"E-Visceral Rhaphsodies (Series)" - 1990

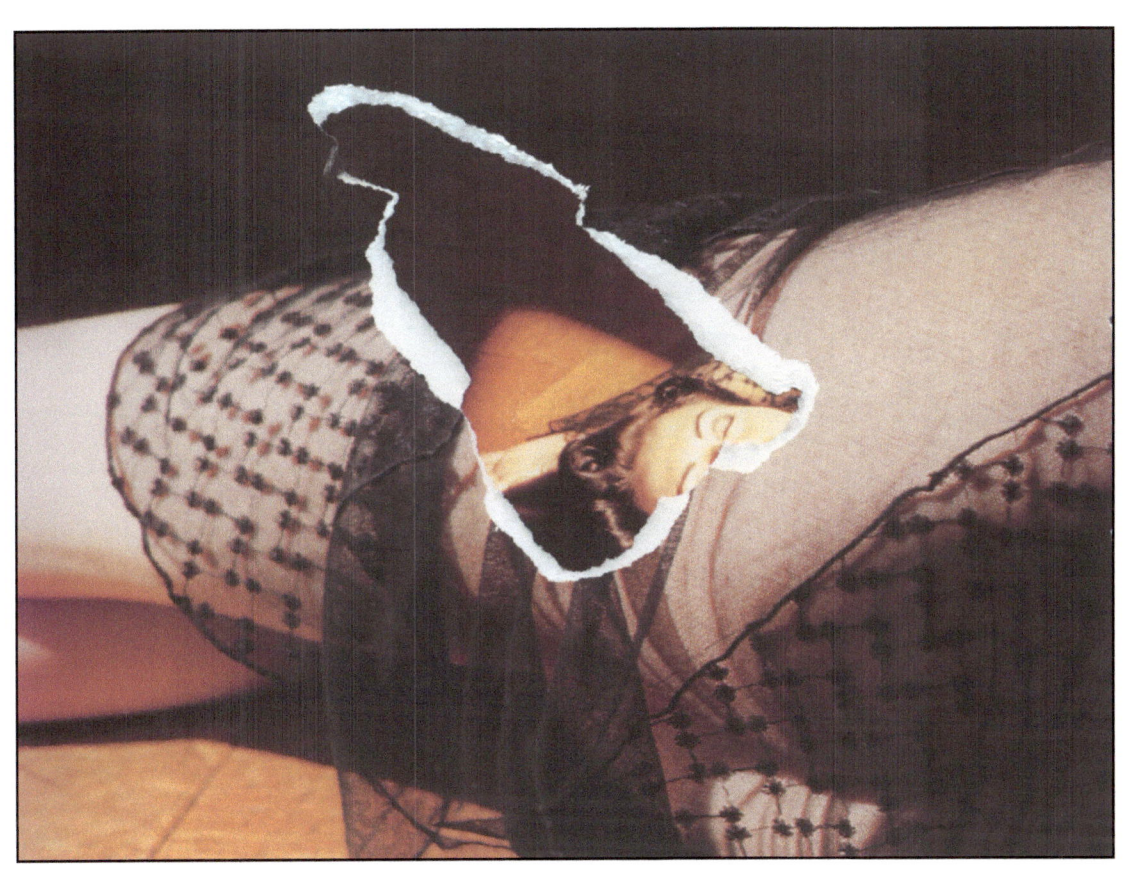

"ES" - Excavation post card - 2006

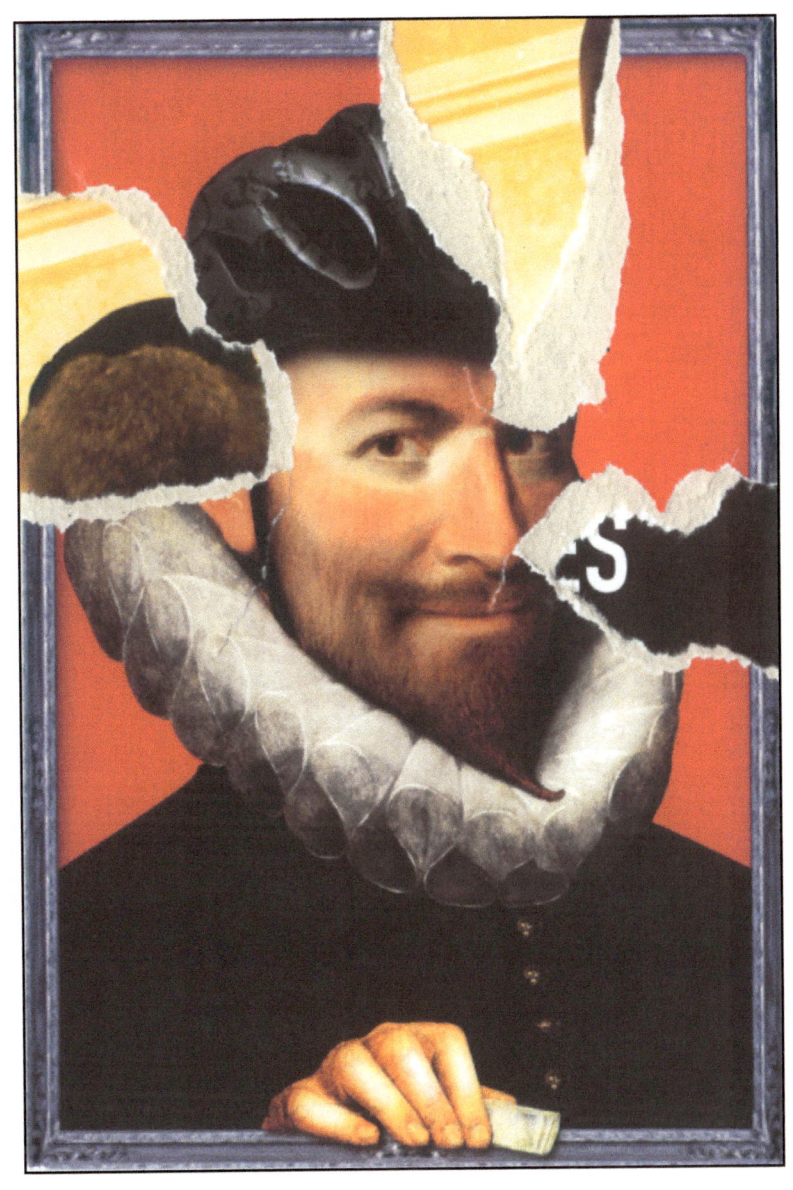

"Currency" - 2006

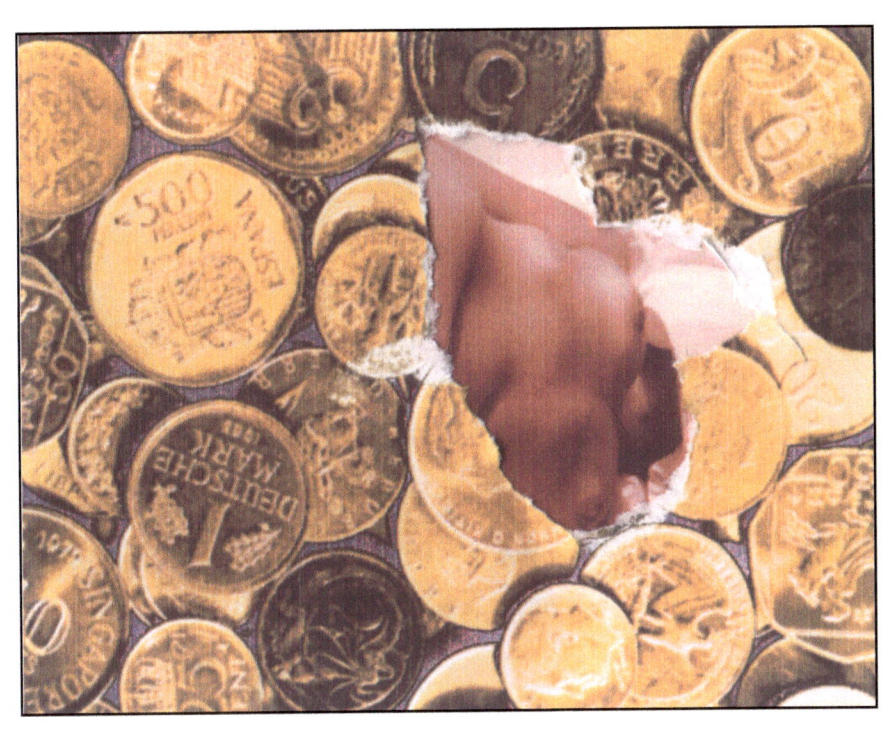

"It's Beautiful Enough the Way it is"
- 2006

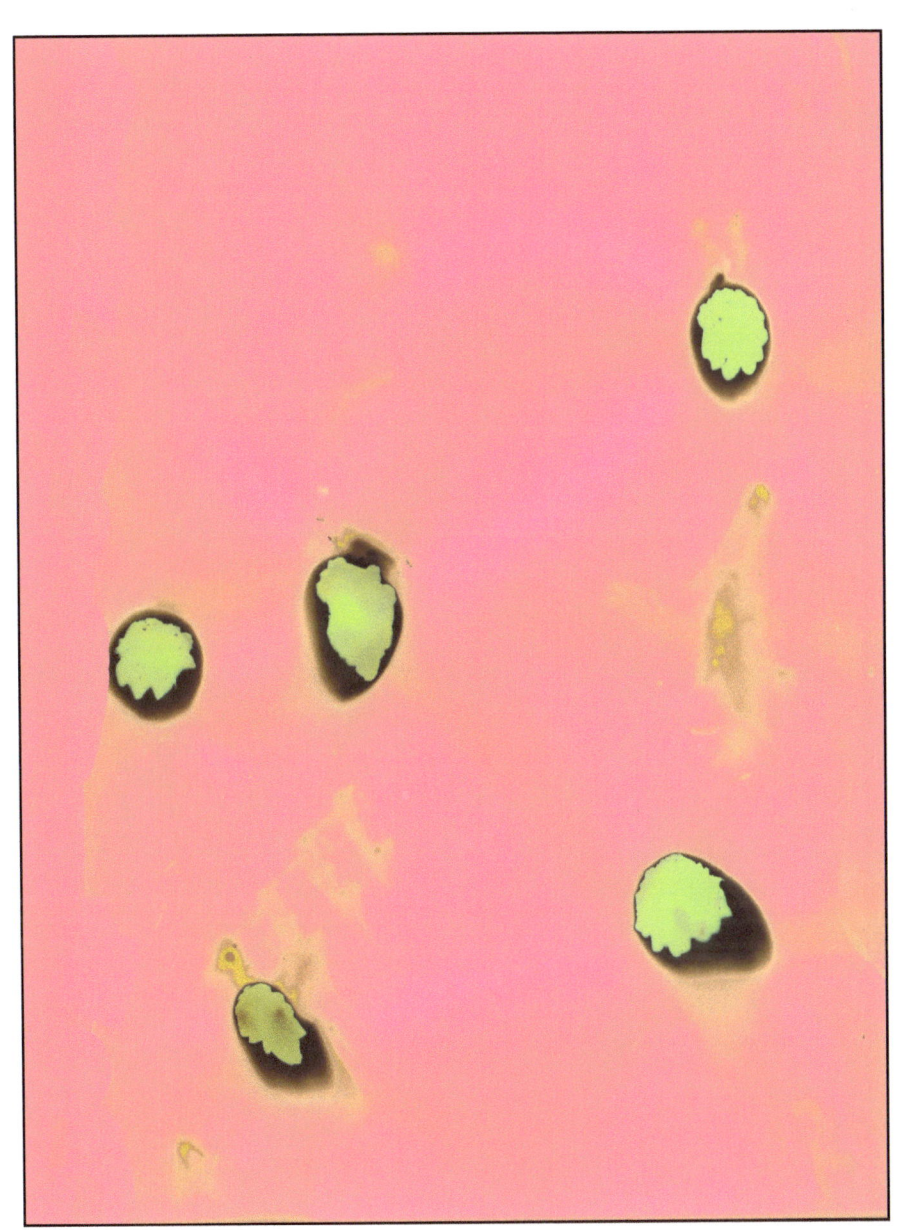

"Butter Torso" - 2006

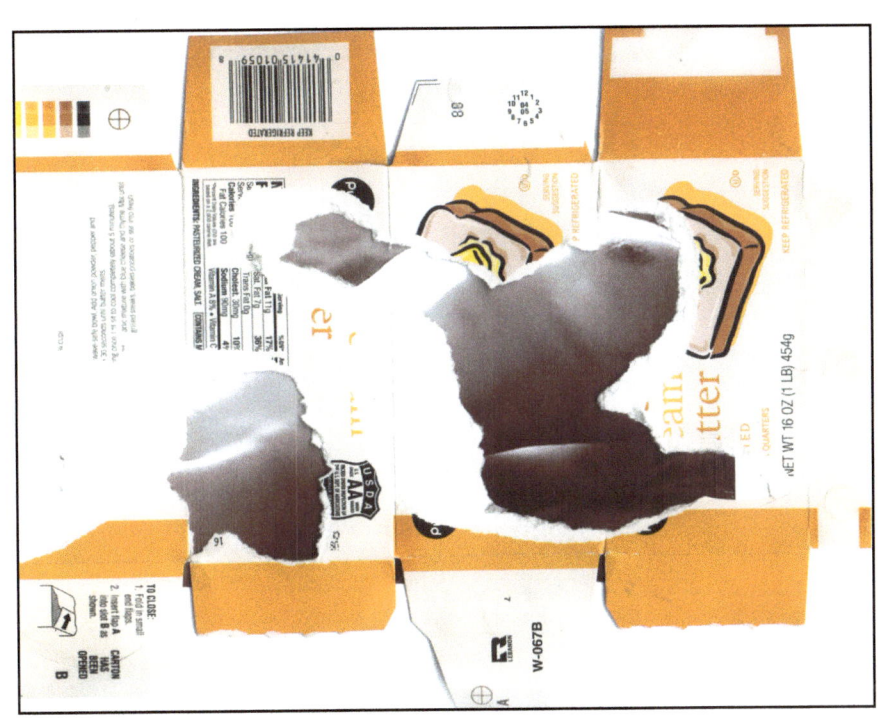

www.ingramcontent.com/pod-product-compliance
Lightning Source LLC
Chambersburg PA
CBHW051101180526
45172CB00002B/727